THE WORLD OF TURNER

FAWCETT COLUMBINE · NEW YORK

A Fawcett Columbine Book
Published by Ballantine Books

First published in Great Britain in 1989 by
Pavilion Books Limited
196 Shaftesbury Avenue, London WC2H 8JL
in association with Michael Joseph Limited
27 Wrights Lane, Kensington, London W8 5TZ

Designed by Bridgewater Design Limited
Cover design by Richard Aquan

ISBN: 0-449-90440-7

Manufactured in Singapore

First American Edition: August 1989

10 9 8 7 6 5 4 3 2 1

FOREWORD

*T*he career of J.M.W. Turner (1775-1851) linked the eighteenth and nineteenth centuries, and his work represents an organic link between classicism and modern art. Yet only in our own day have his range and stature been fully appreciated.

The precocious young painter who began as a watercolorist in the Gainsborough tradition was equally receptive to such contrasting influences as Claude, Poussin, the Dutch marine school, and the Italian masters. Through study, observation and travel he absorbed those influences into a unique personal synthesis which he never ceased to develop. In Turner's art all subject-matter, whether classical, historical, or contemporary, is merged into the landscape and subordinated to the dramatic and often violent effects of nature. It was above all the problem of light which occupied him, whether in the tranquility of his dreamlike Venetian scenes, the awesome fury of his storms, or the increasing abstraction of later work such as *Norham Castle, Sunrise*. Technically he can now be seen as a modernist, but in his lyricism, his sense of the tragic, his fascination with the dramatic and sublime, he was by temperament a Romantic.

Turner's final gesture was to bequeath his entire collection to the nation, with the condition that it should all be housed together. In 1987, the Tate Gallery, by Turner's beloved Thames, opened the Clore Gallery for this purpose, and all of the following paintings are from that collection. At last, the old hero of English painting had received his due.

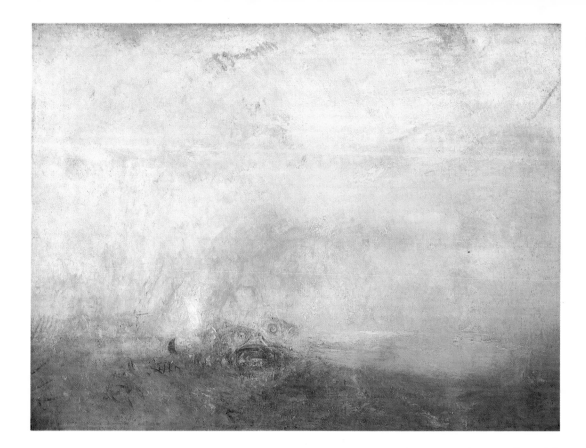

J . M . W . T U R N E R (1775-1851)
Sunrise with Sea Monsters (c. 1845)
THE TATE GALLERY, LONDON

FAWCETT COLUMBINE · NEW YORK

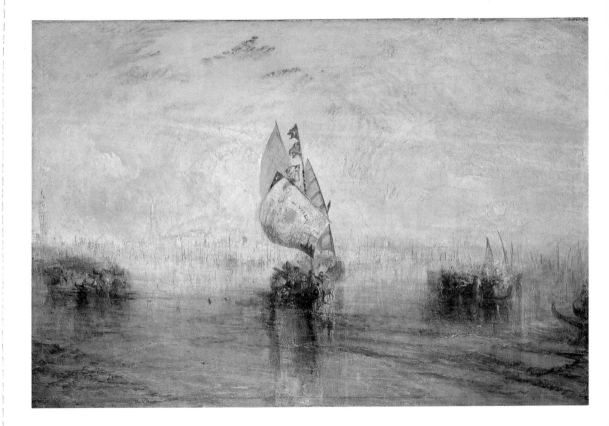

J . M . W .T U R N E R (1775-1851)
The Sun of Venice going to Sea (exh. 1843)
THE TATE GALLERY, LONDON

F A W C E T T C O L U M B I N E · N E W Y O R K

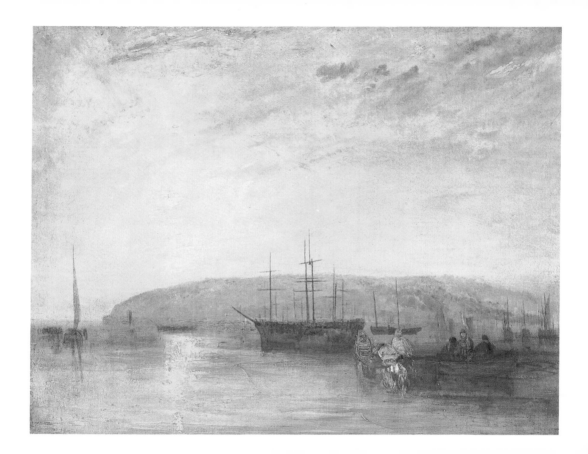

J . M . W . T U R N E R (1775-1851)
Shipping off East Cowes Headland (1827)
THE TATE GALLERY, LONDON

F A W C E T T C O L U M B I N E · N E W Y O R K

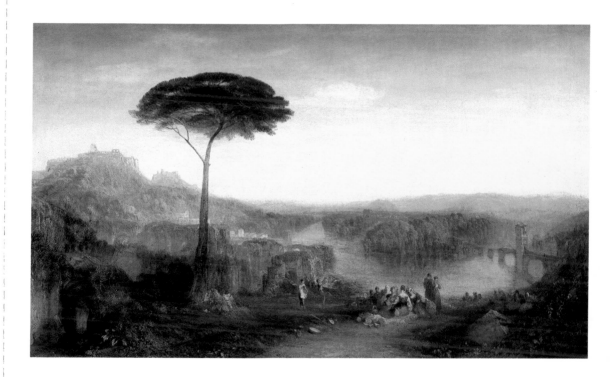

J . M . W . T U R N E R (1775-1851)
Childe Harold's Pilgrimage: Italy (exh. 1832)
THE TATE GALLERY, LONDON

F A W C E T T C O L U M B I N E · N E W Y O R K

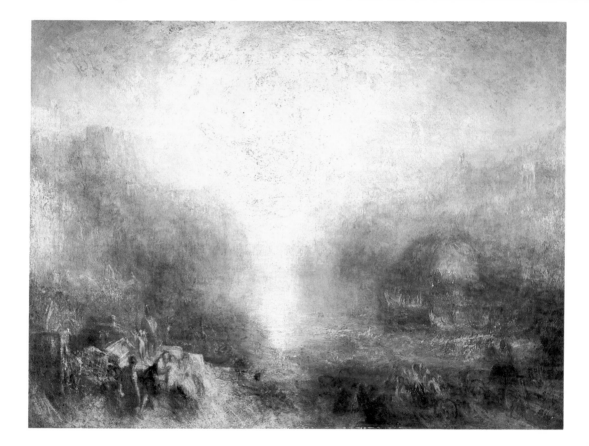

J . M . W . T U R N E R (1775-1851)
Mercury sent to admonish Aeneas (exh. 1850)
THE TATE GALLERY, LONDON

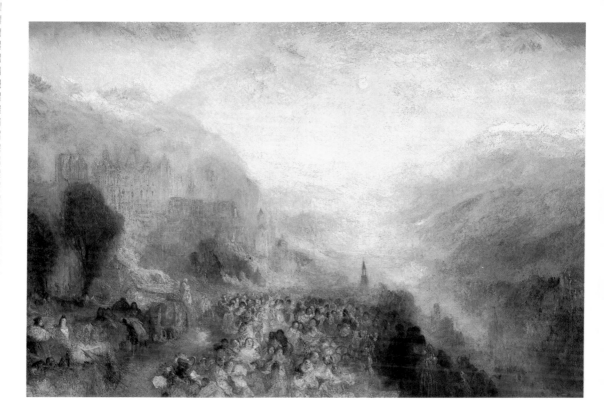

J . M . W . T U R N E R (1775-1851)
Heidelberg (c. 1840-5)
THE TATE GALLERY, LONDON

F A W C E T T C O L U M B I N E · N E W Y O R K

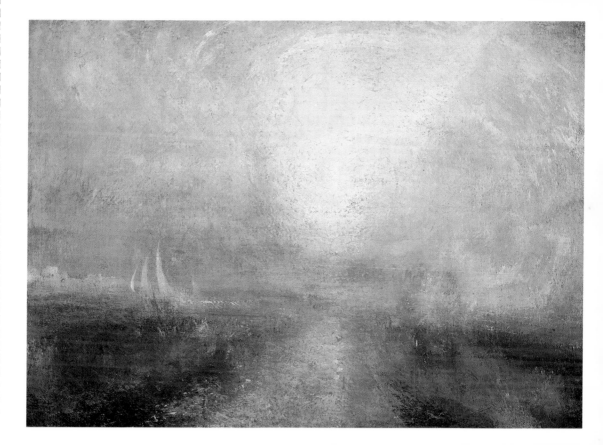

J . M . W . TURNER (1775-1851)
Yacht approaching the Coast (c. 1835-40)
THE TATE GALLERY, LONDON

FAWCETT COLUMBINE · NEW YORK

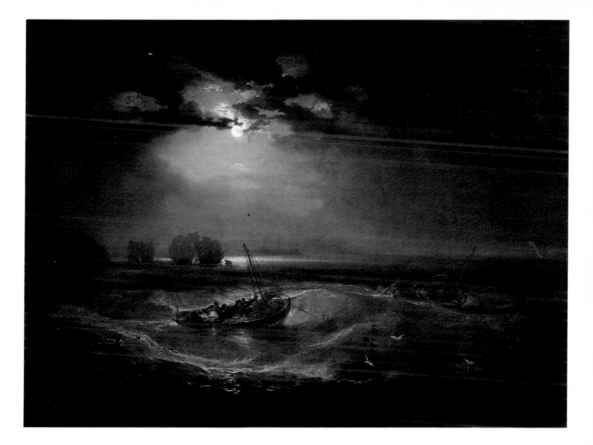

J . M . W . TURNER (1775-1851)
Fishermen at Sea (exh. 1796)
THE TATE GALLERY, LONDON

FAWCETT COLUMBINE · NEW YORK

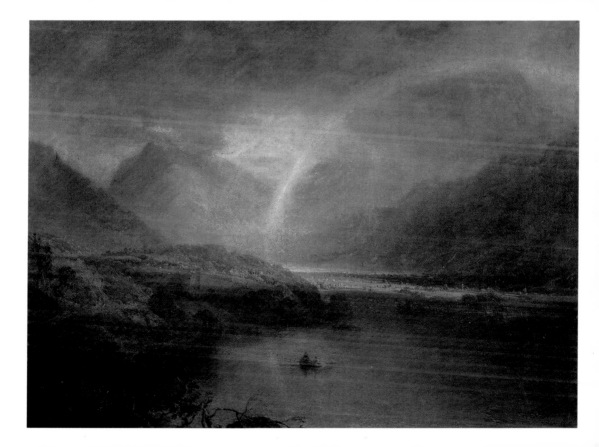

J . M . W . TURNER (1775-1851)
Buttermere Lake, with part of Cromackwater, Cumberland, a Shower
(exh. 1798)
THE TATE GALLERY, LONDON

FAWCETT COLUMBINE · NEW YORK

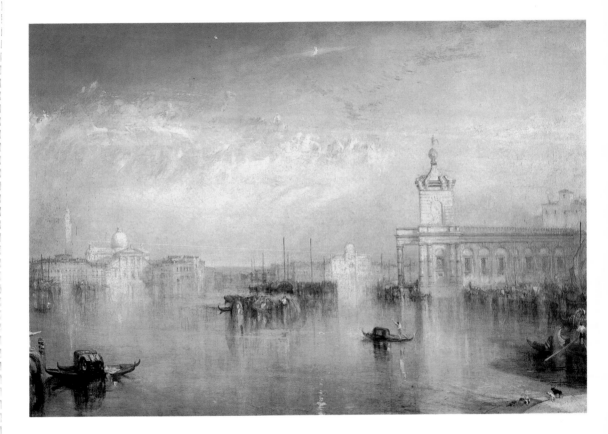

J . M . W . TURNER (1775-1851)
The Dogana, San Giorgio, Citella, from Steps of the Europa (exh. 1842)
THE TATE GALLERY, LONDON

FAWCETT COLUMBINE · NEW YORK

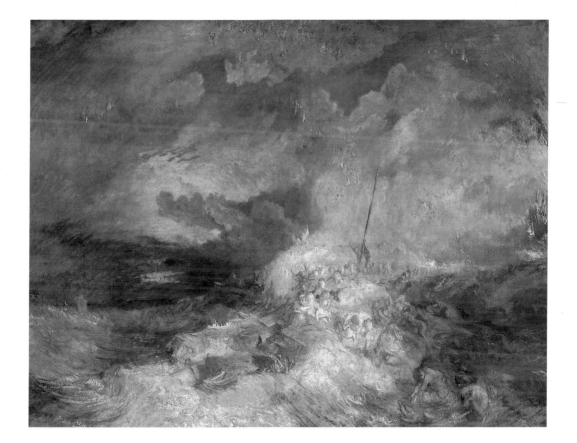

J . M . W . T U R N E R (1775-1851)
A Fire at Sea (?c. 1835)
THE TATE GALLERY, LONDON

F A W C E T T C O L U M B I N E · N E W Y O R K

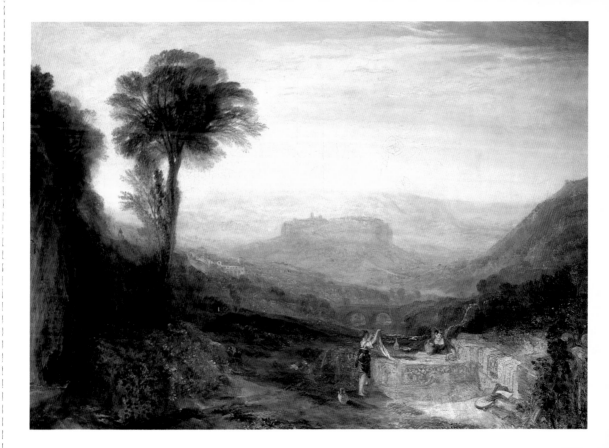

J . M . W . TURNER (1775-1851)
View of Orvieto, painted in Rome (1828)
THE TATE GALLERY, LONDON

FAWCETT COLUMBINE · NEW YORK

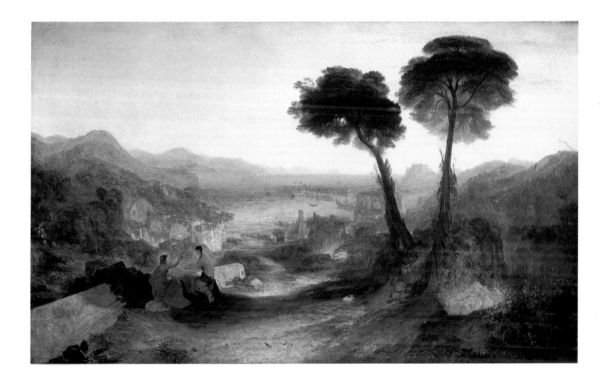

J . M . W . TURNER (1775-1851)
The Bay of Baiae, with Apollo and the Sibyl (exh. 1823)
THE TATE GALLERY, LONDON

FAWCETT COLUMBINE · NEW YORK

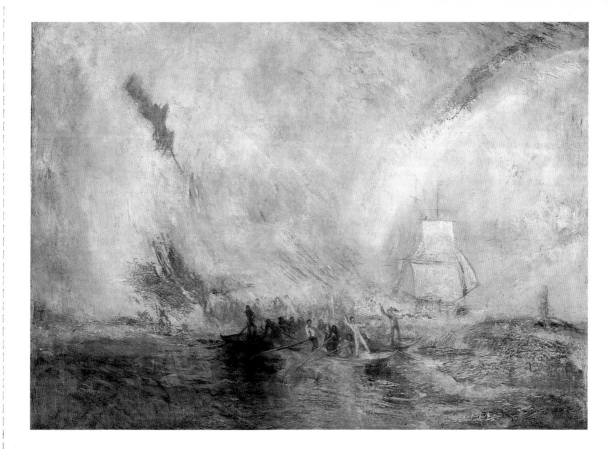

J . M . W . TURNER (1775-1851)
Whalers (exh. 1845)
THE TATE GALLERY, LONDON

FAWCETT COLUMBINE · NEW YORK

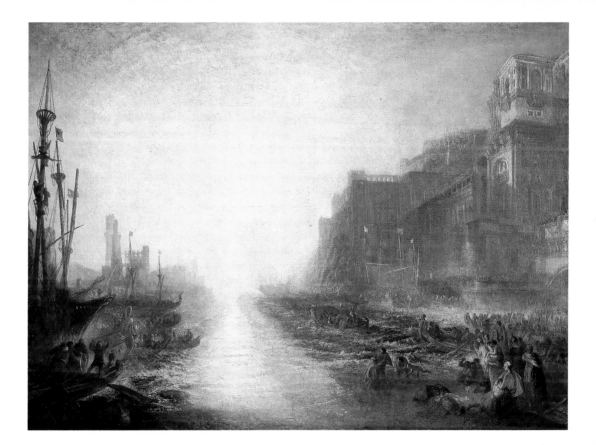

J . M . W . T U R N E R (1775-1851)
Regulus (1828, reworked 1837)
THE TATE GALLERY, LONDON

F A W C E T T C O L U M B I N E · N E W Y O R K

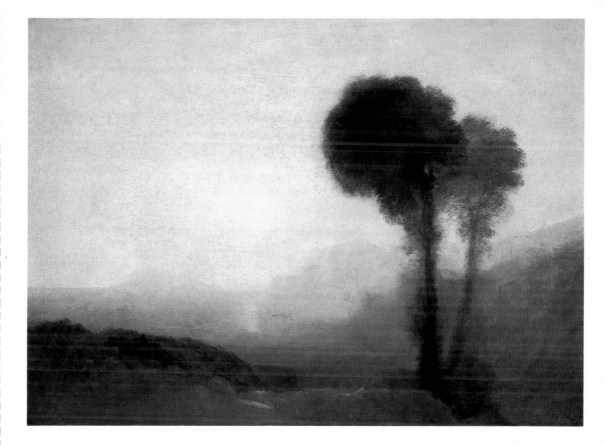

J . M . W . TURNER (1775-1851)
Coast Scene near Naples (?1828)
THE TATE GALLERY, LONDON

FAWCETT COLUMBINE · NEW YORK

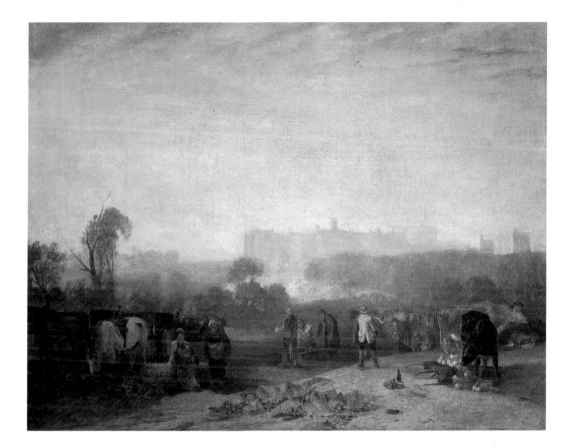

J.M.W. TURNER (1775-1851)
Ploughing up Turnips, near Slough ('Windsor') (exh. 1809)
THE TATE GALLERY, LONDON

FAWCETT COLUMBINE · NEW YORK

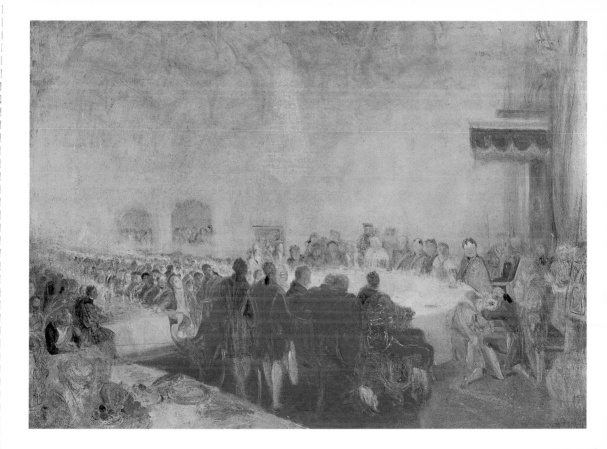

J . M . W . TURNER (1775-1851)
George IV at the Provost's Banquet in the Parliament House, Edinburgh
(c. 1822)
THE TATE GALLERY, LONDON

FAWCETT COLUMBINE · NEW YORK

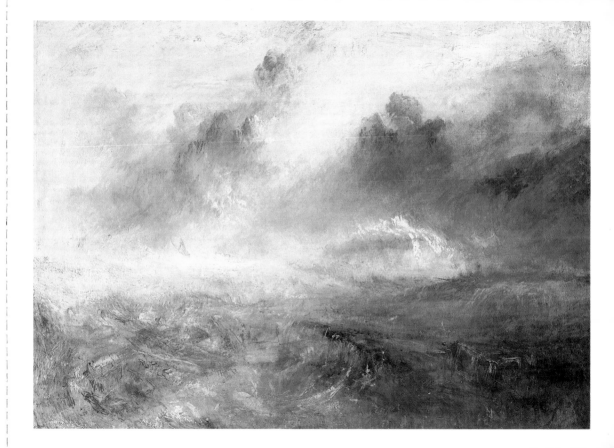

J . M . W . T U R N E R (1775-1851)
Rough Sea with Wreckage (c. 1830-5)
THE TATE GALLERY, LONDON

F A W C E T T C O L U M B I N E · N E W Y O R K

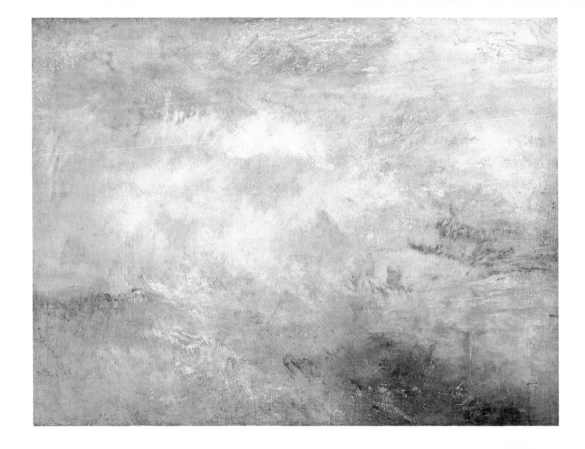

J . M . W . TURNER (1775-1851)
Stormy Sea with Dolphins (c. 1835-40)
THE TATE GALLERY, LONDON

FAWCETT COLUMBINE · NEW YORK

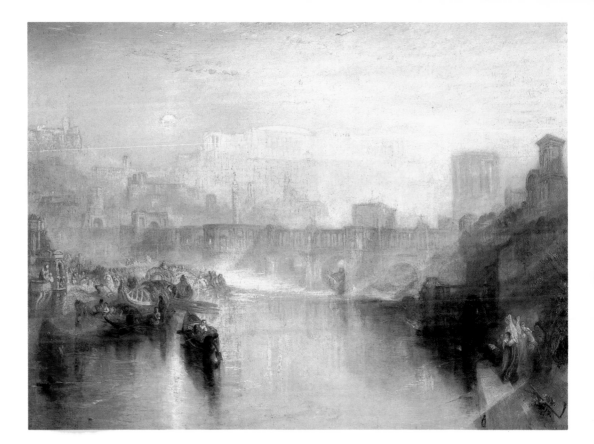

J . M . W . T U R N E R (1775-1851)
Ancient Rome; Agrippina landing with the Ashes of Germanicus (exh. 1839)
THE TATE GALLERY, LONDON

F A W C E T T C O L U M B I N E · N E W Y O R K

J . M . W . T U R N E R (1775-1851)
Sunrise, with a boat between Headlands (c. 1840-5)
THE TATE GALLERY, LONDON

F A W C E T T C O L U M B I N E · N E W Y O R K

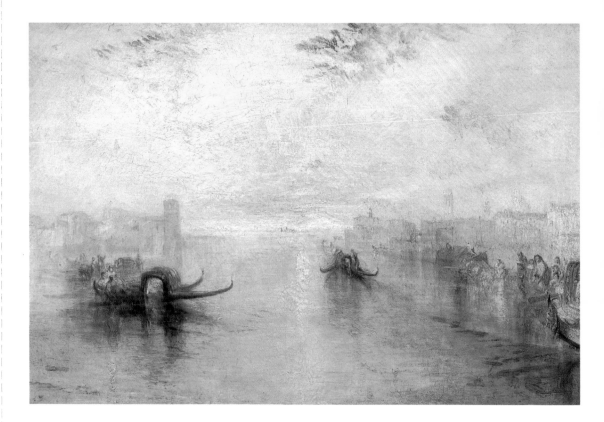

J . M . W . T U R N E R (1775-1851)
St. Benedetto, looking towards Fusina (exh. 1843)
THE TATE GALLERY, LONDON

F A W C E T T C O L U M B I N E · N E W Y O R K

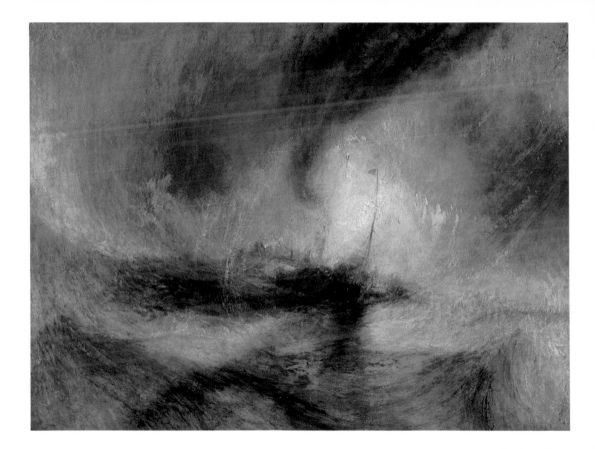

J . M . W . TURNER (1775-1851)
Snow Storm: Steam-Boat off a Harbour's Mouth (exh. 1842)
THE TATE GALLERY, LONDON

FAWCETT COLUMBINE · NEW YORK

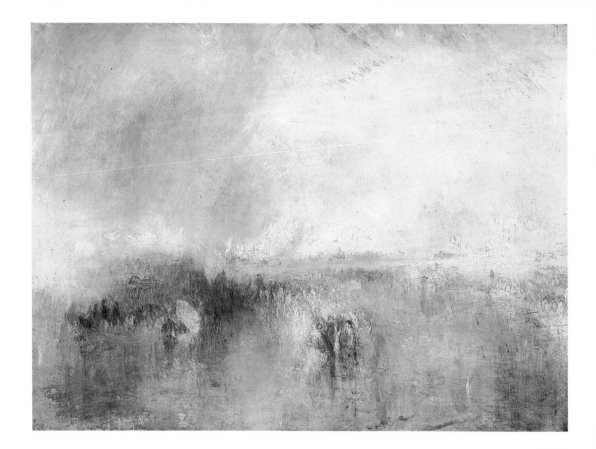

J . M . W . TURNER (1775-1851)
Procession of Boats with Distant Smoke, Venice (c. 1845)
THE TATE GALLERY, LONDON

FAWCETT COLUMBINE · NEW YORK

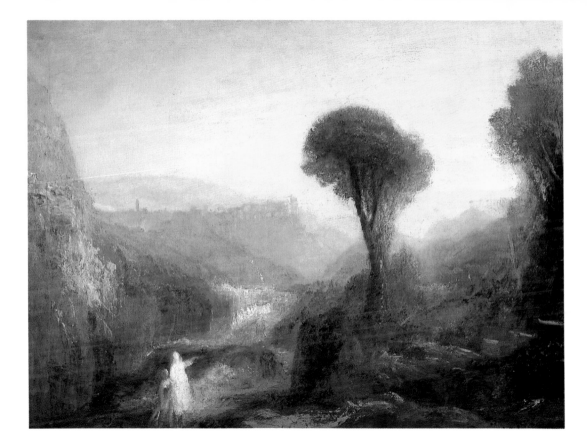

J. M. W. TURNER (1775-1851)
Tivoli: Tobias and the Angel (c. 1835)
THE TATE GALLERY, LONDON

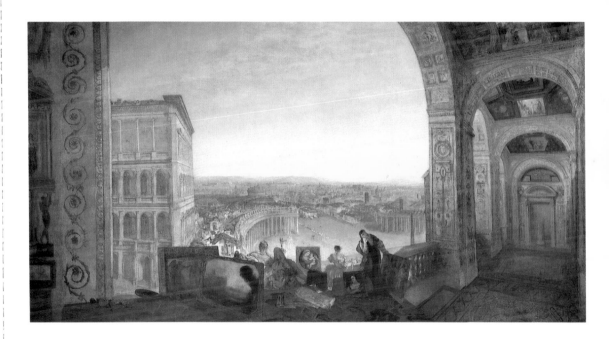

J . M . W . TURNER (1775-1851)
Rome, from the Vatican. Raffaelle, accompanied by La Fornarina, preparing his Pictures for the Decoration of the Loggia (exh. 1820)
THE TATE GALLERY, LONDON

FAWCETT COLUMBINE · NEW YORK

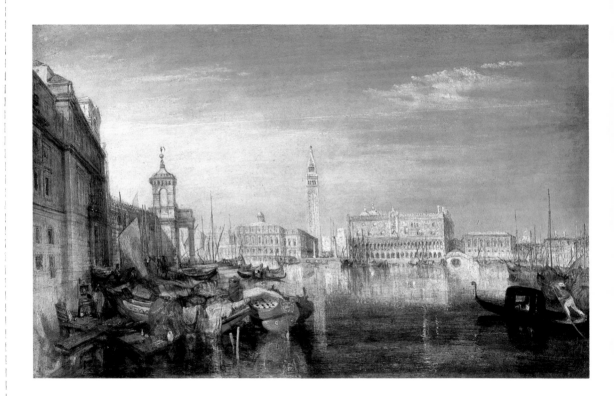

J . M . W . T U R N E R (1775-1851)
Bridge of Sighs, Ducal Palace and Custom-House, Venice: Canaletti Painting (exh. 1833)
THE TATE GALLERY, LONDON

F A W C E T T C O L U M B I N E · N E W Y O R K

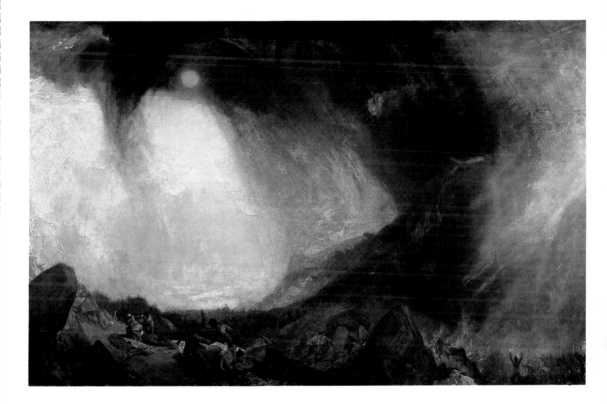

J . M . W . TURNER (1775-1851)
Snowstorm: Hannibal and his Army crossing the Alps (exh. 1812)
THE TATE GALLERY, LONDON

FAWCETT COLUMBINE · NEW YORK

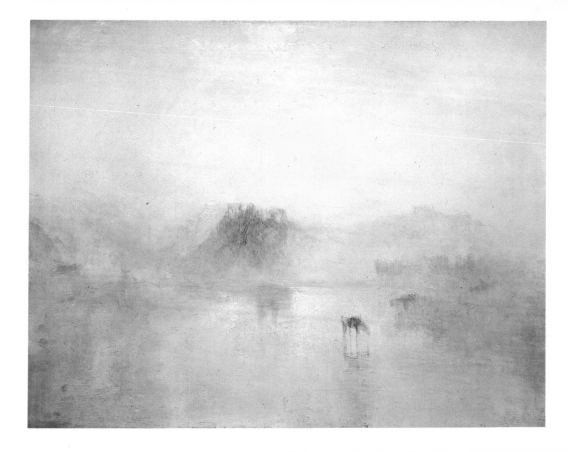

J . M . W . T U R N E R (1775-1851)
Norham Castle, Sunrise (c. 1845)
THE TATE GALLERY, LONDON

F A W C E T T C O L U M B I N E · N E W Y O R K